TOO SEXY
BY FAR

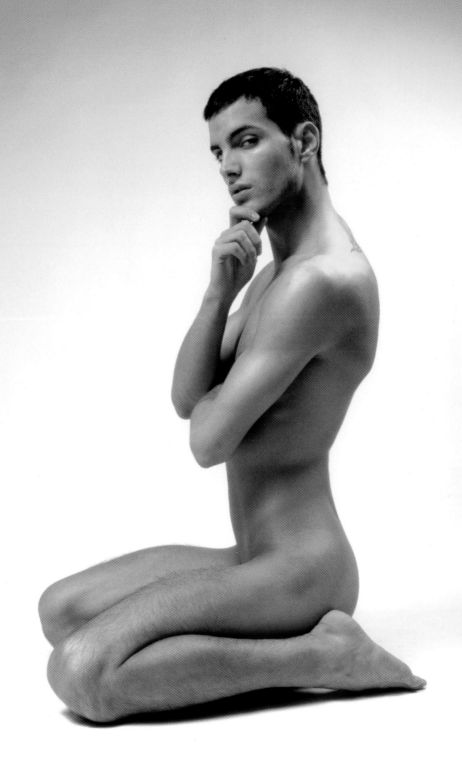

Bruno Gmünder

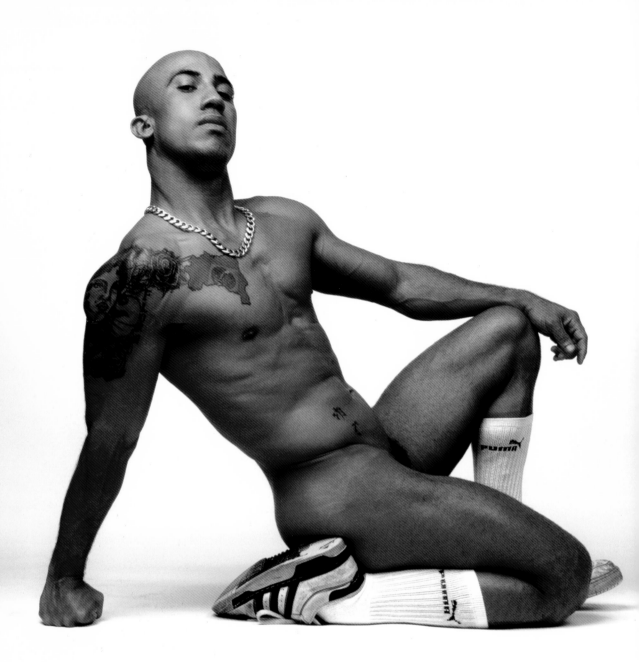

SO SEXY IT HURTS

[Patrick Mettraux]

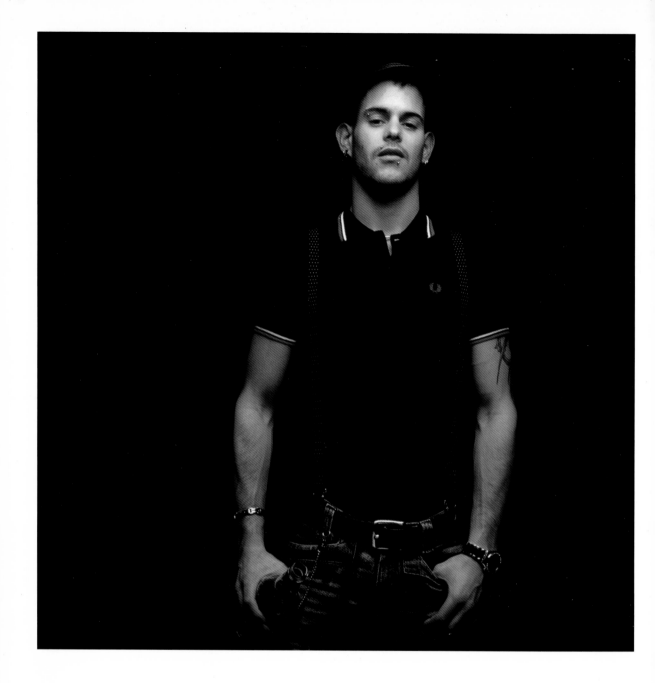

[intro]

Patrick Mettraux, a photographer who celebrates the beauty of urban youth. Wild or tender, he presents a breathtaking work centred on a world where fashion meets erotic. Brought together for the first time, his pictures reflect the complex versatility of his sense of aesthetic. Spontaneous creations, just for the pleasure of being impossible, drawn by an inner fire where heaven should be on earth. Bad boys, elegant models and urban lads come together to elaborate a rare visual experience.

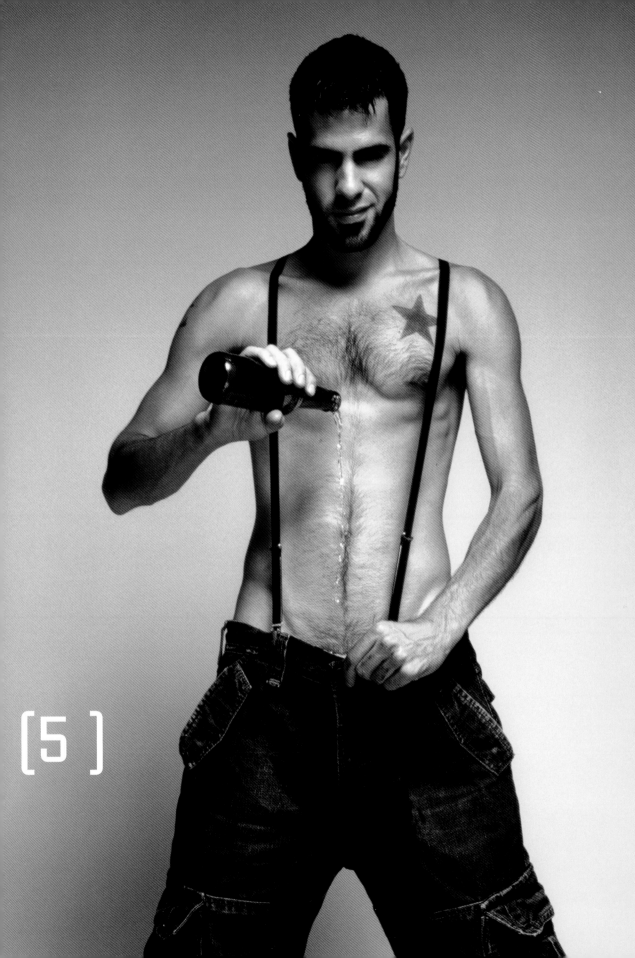

[5]

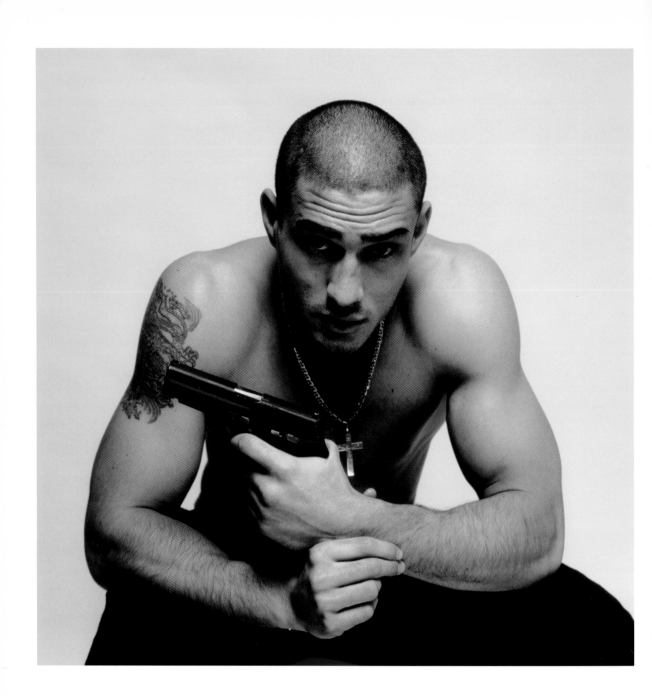

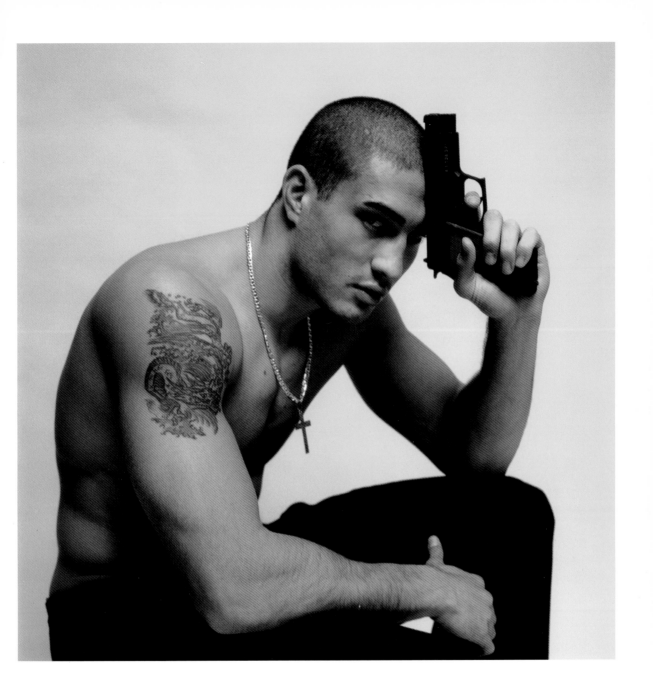

[7]

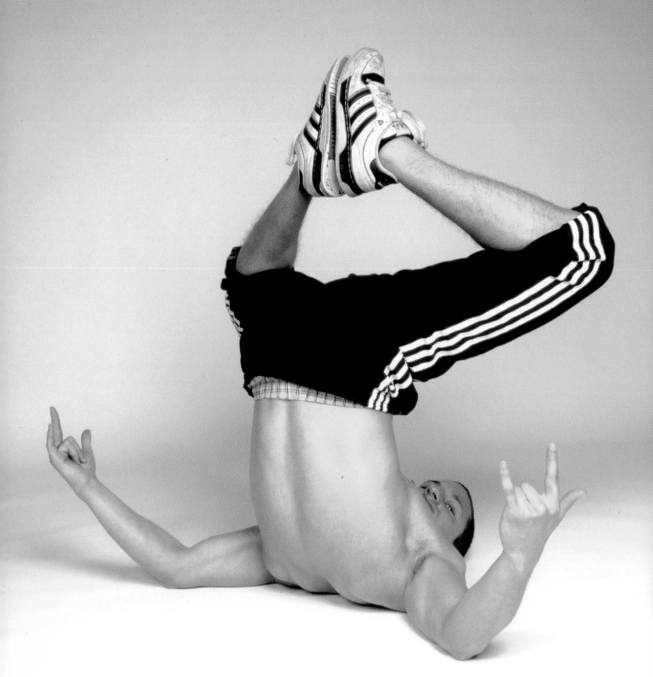

[8]

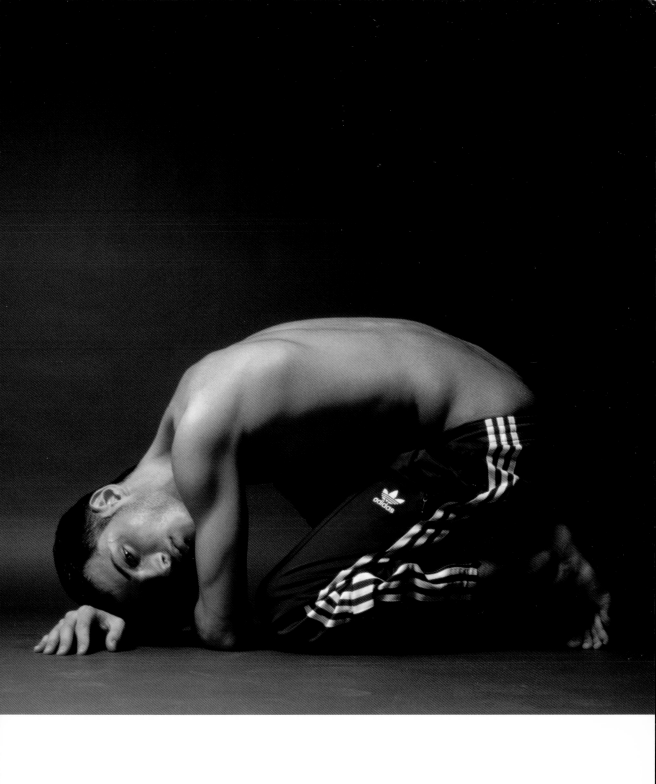

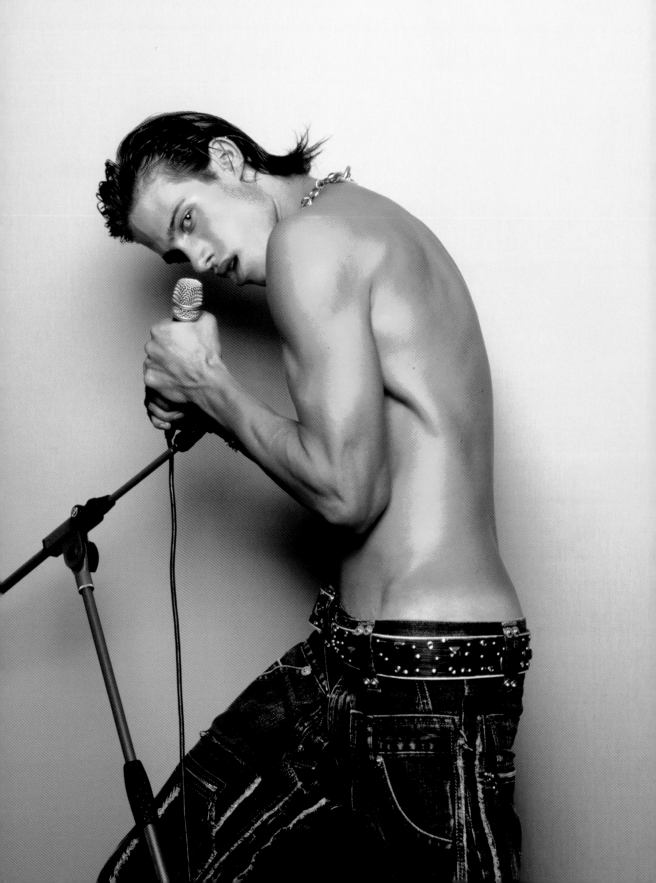

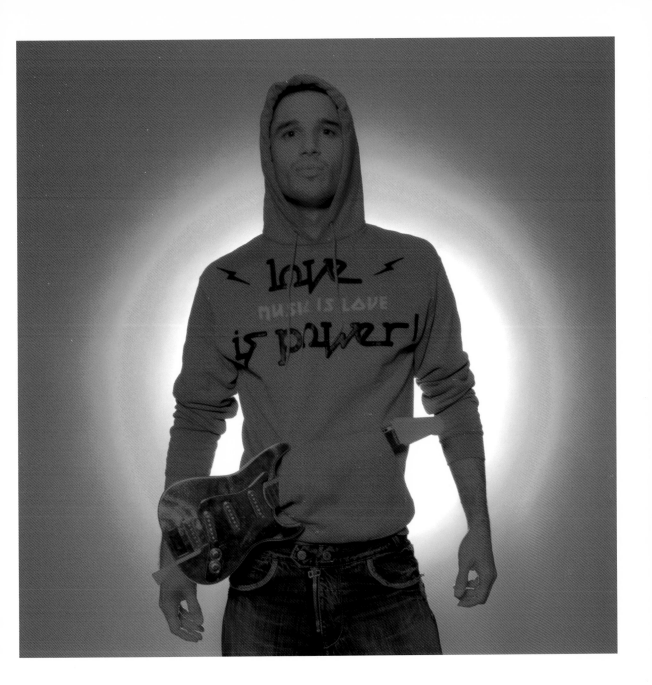

[11]

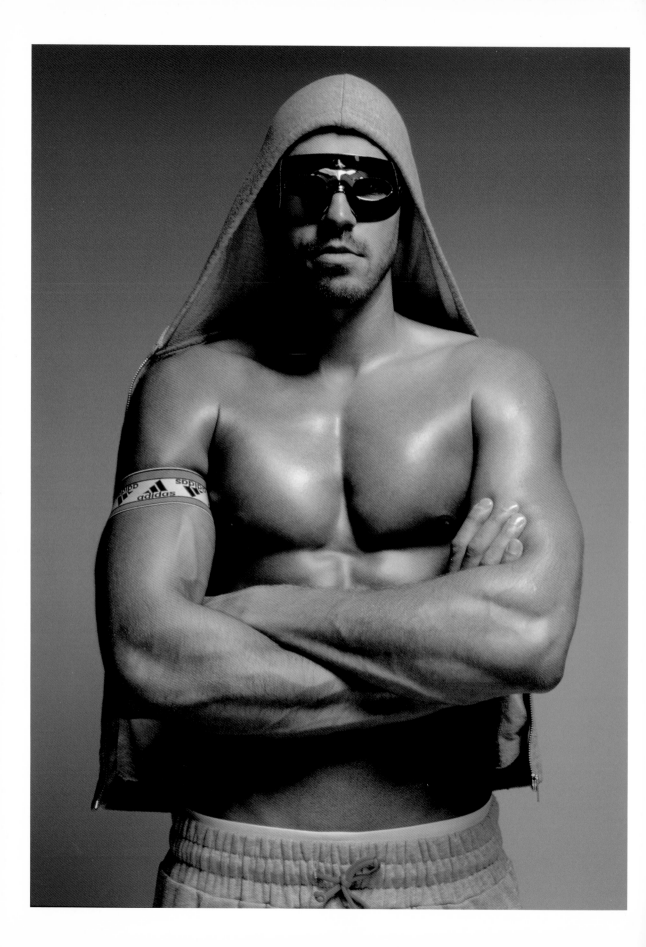

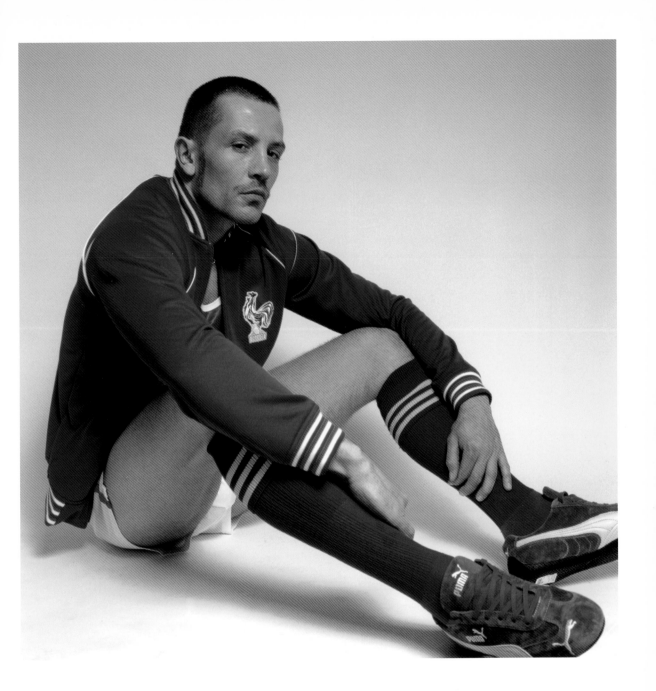

[13]

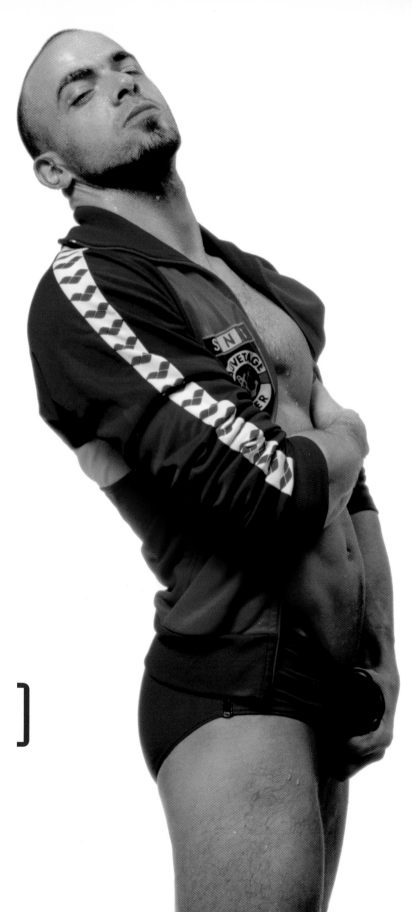

[14]

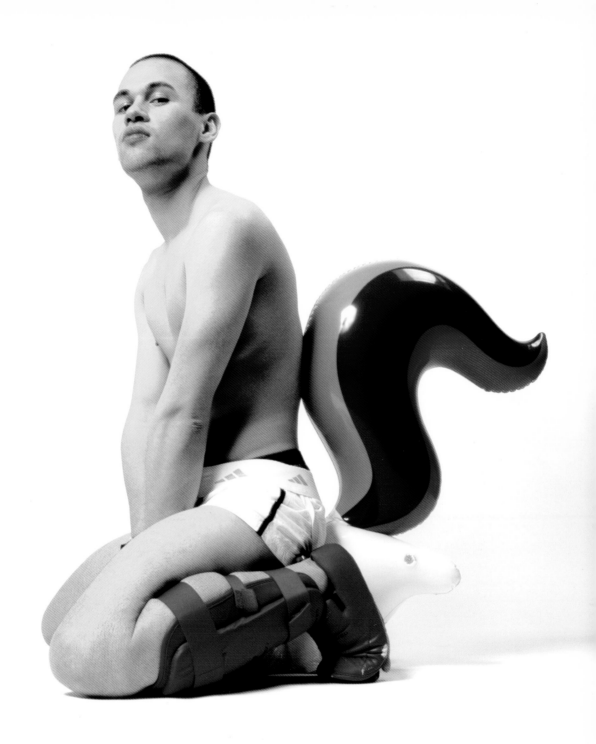

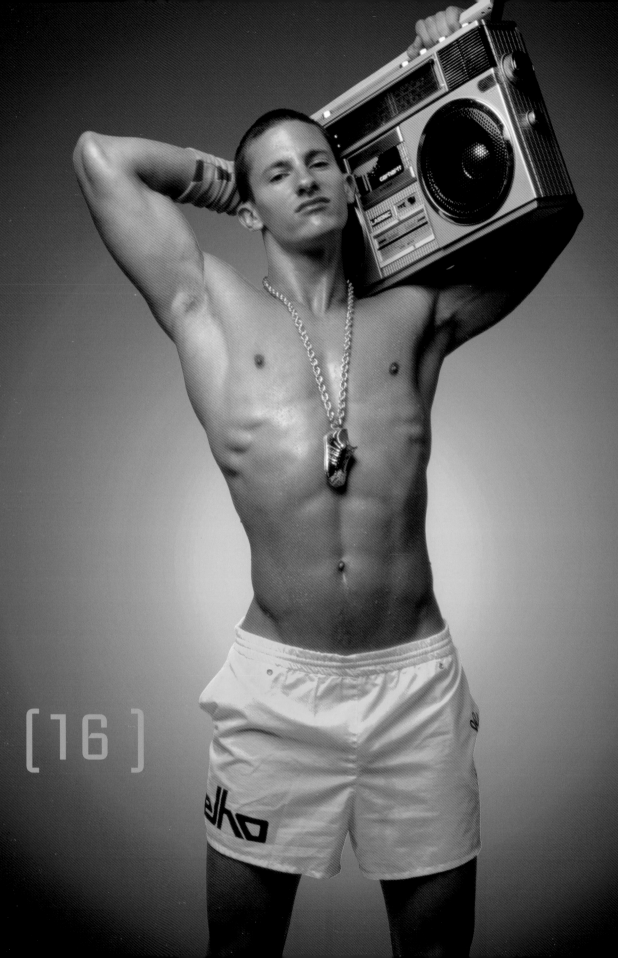

[16]

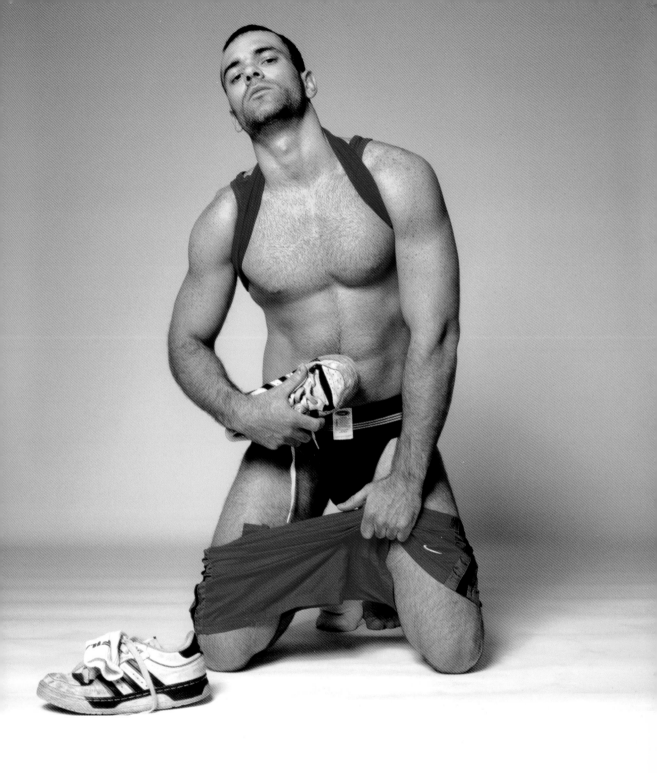

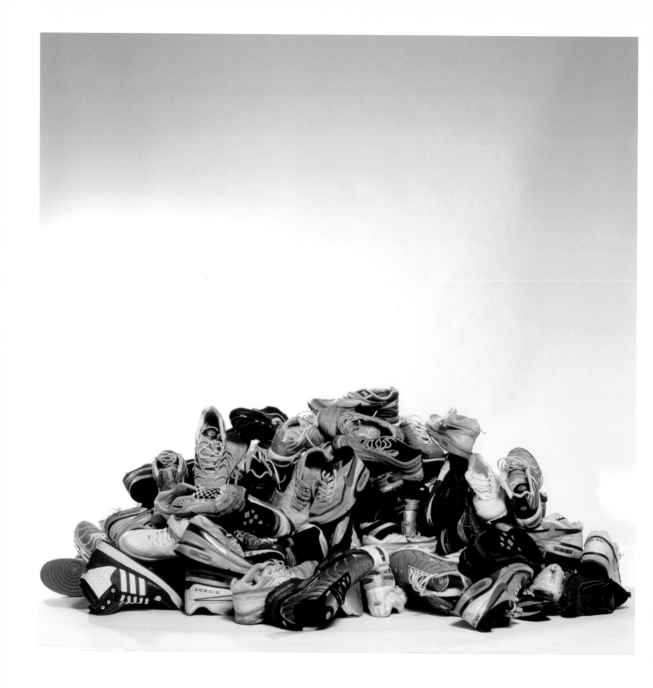

[20]

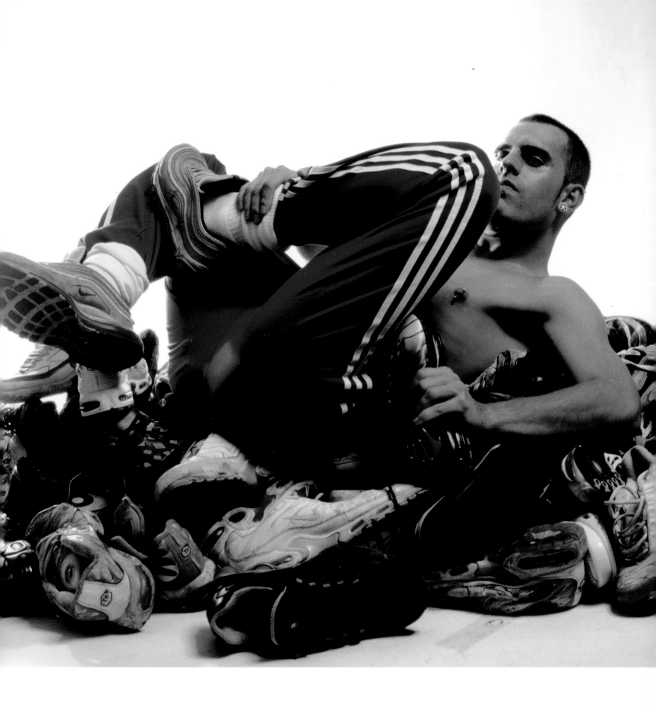

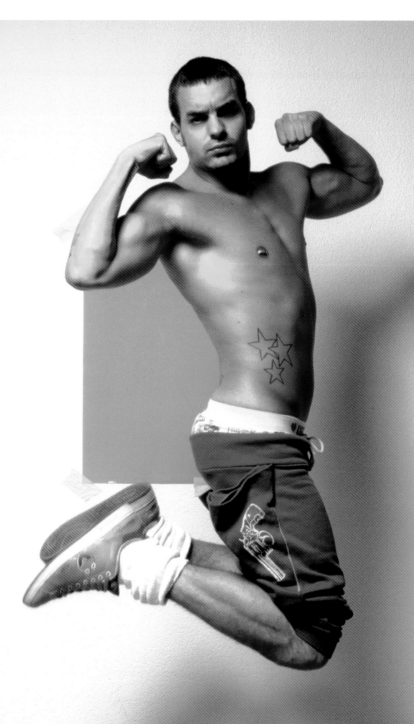

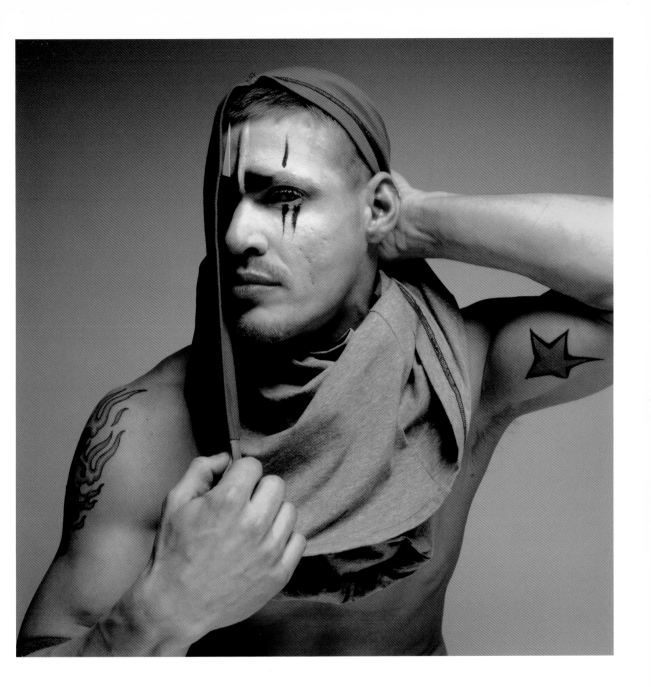

[23]

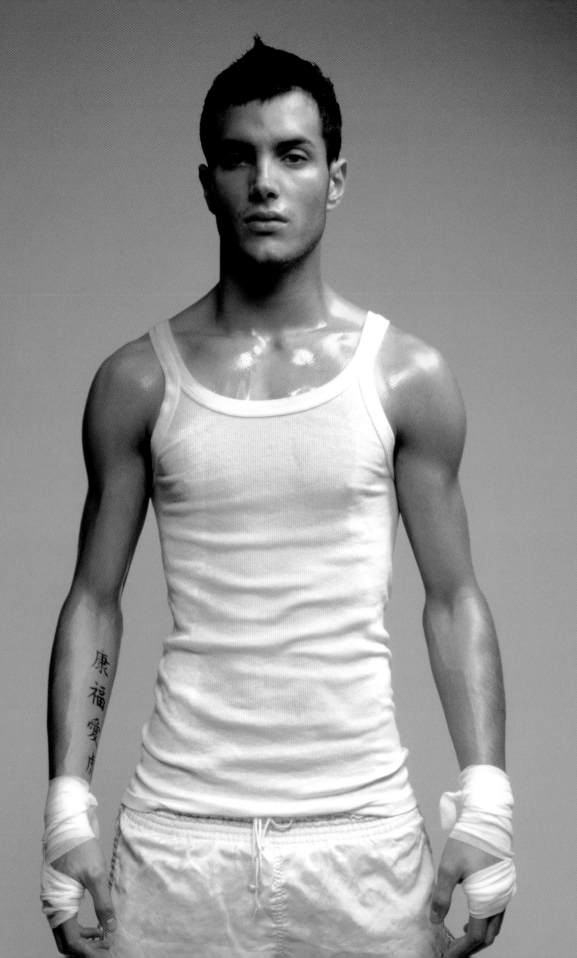

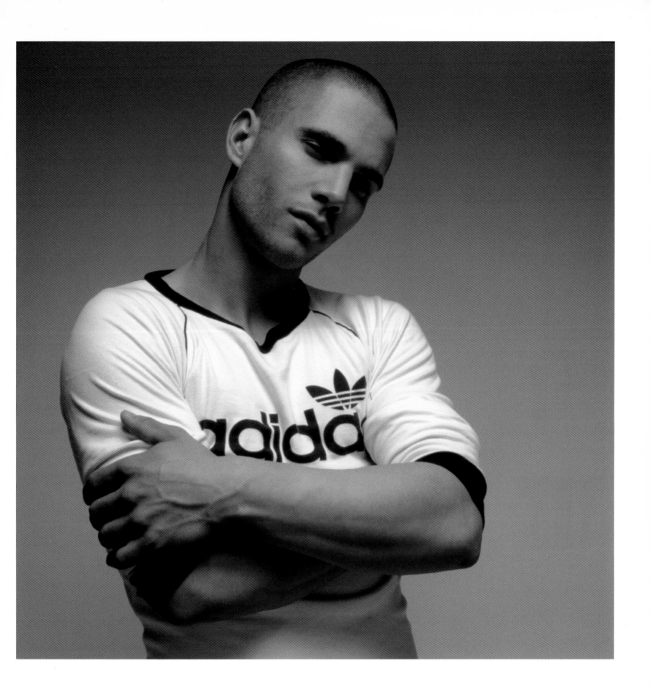

[25]

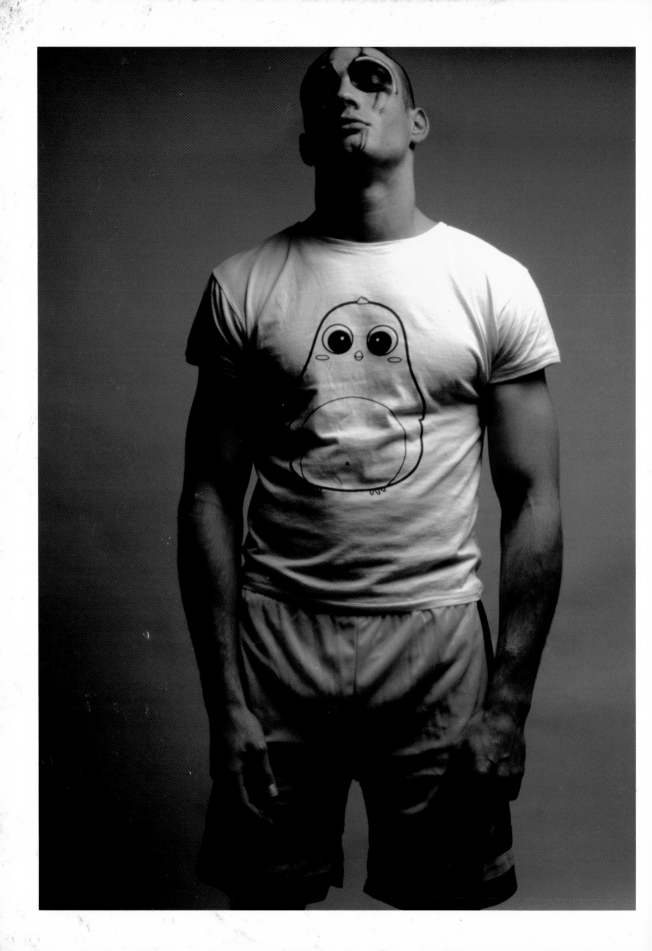

[28]

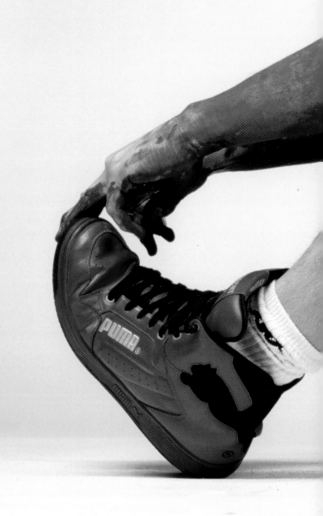

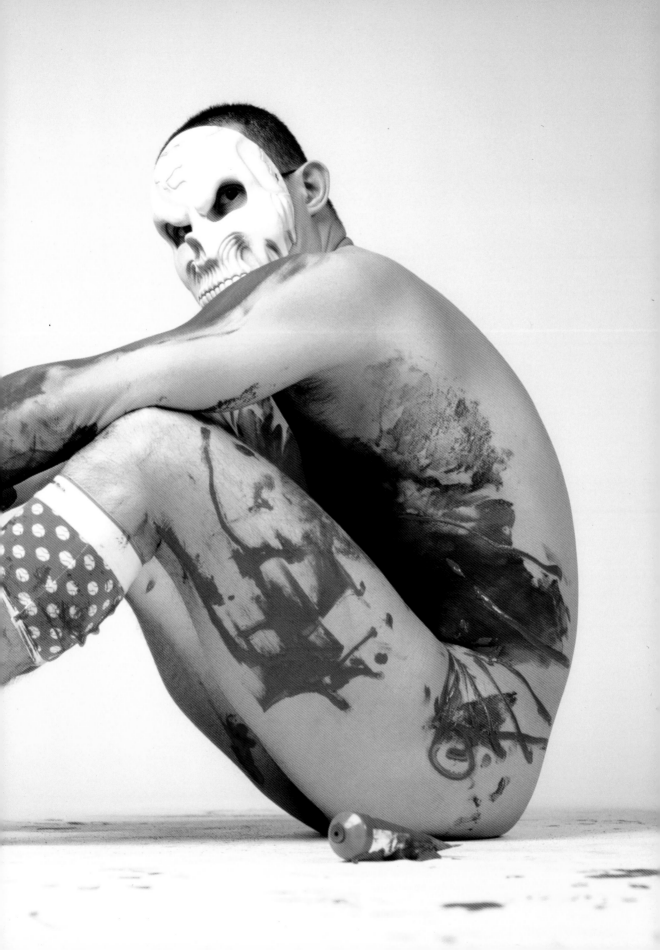

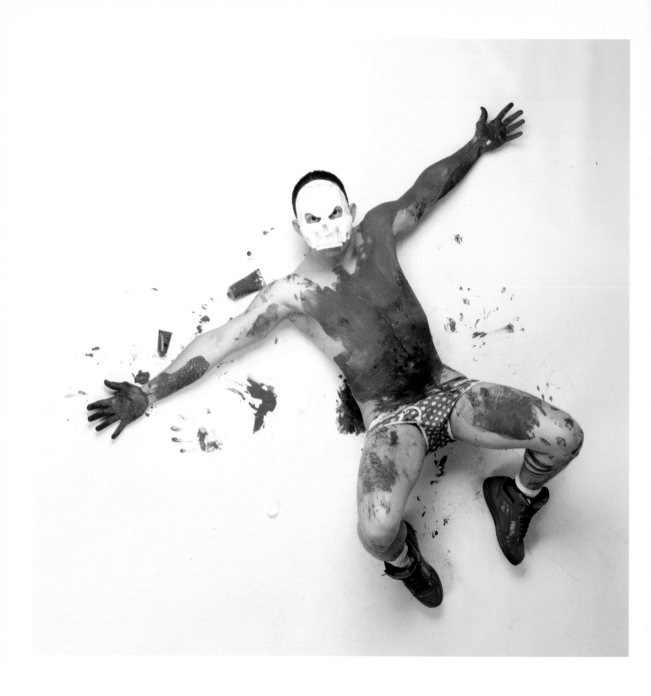

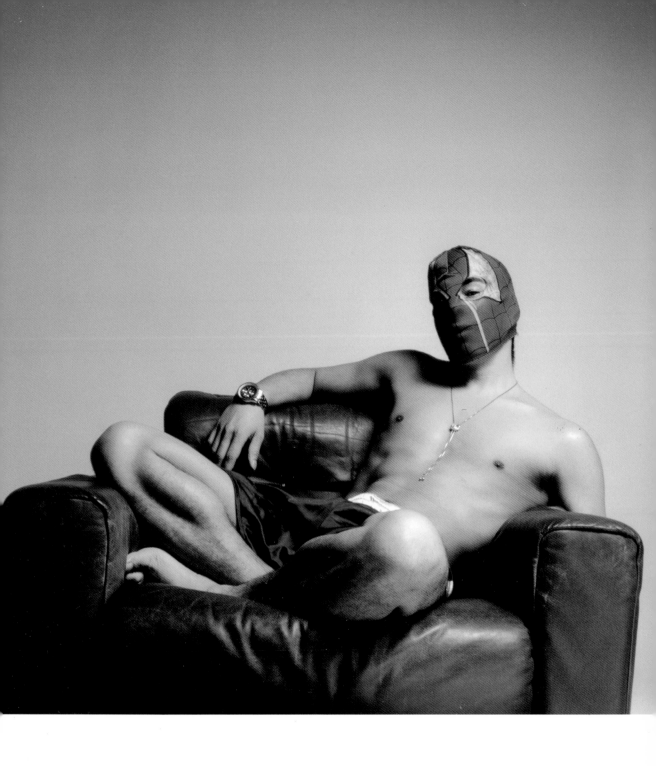

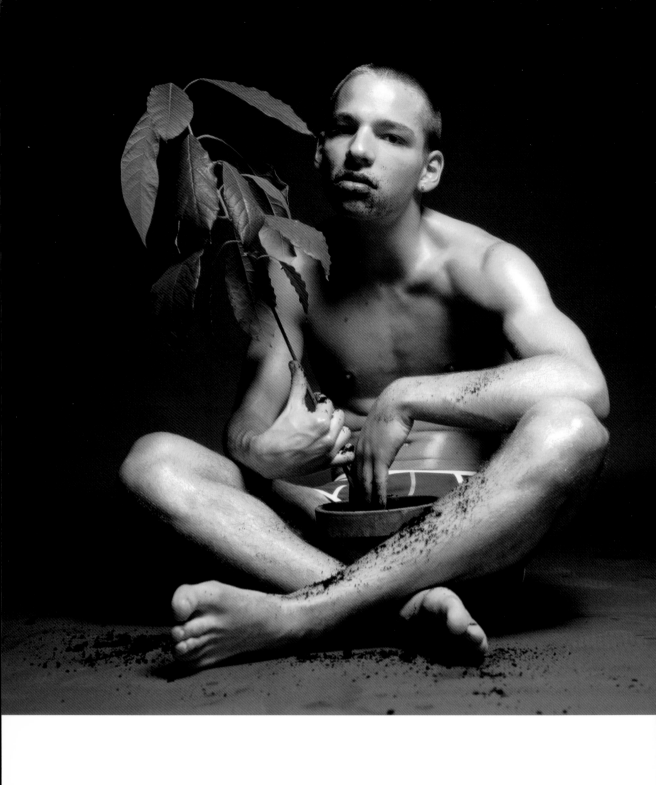

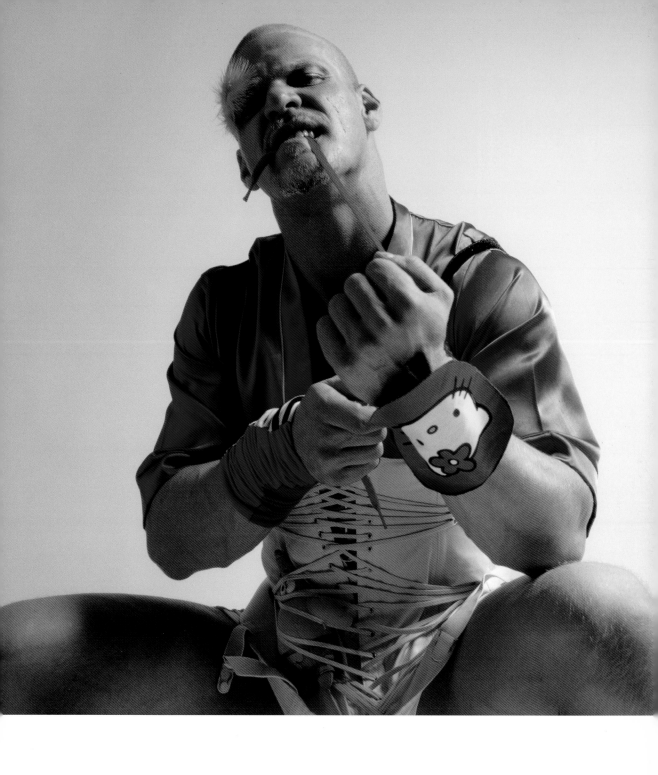

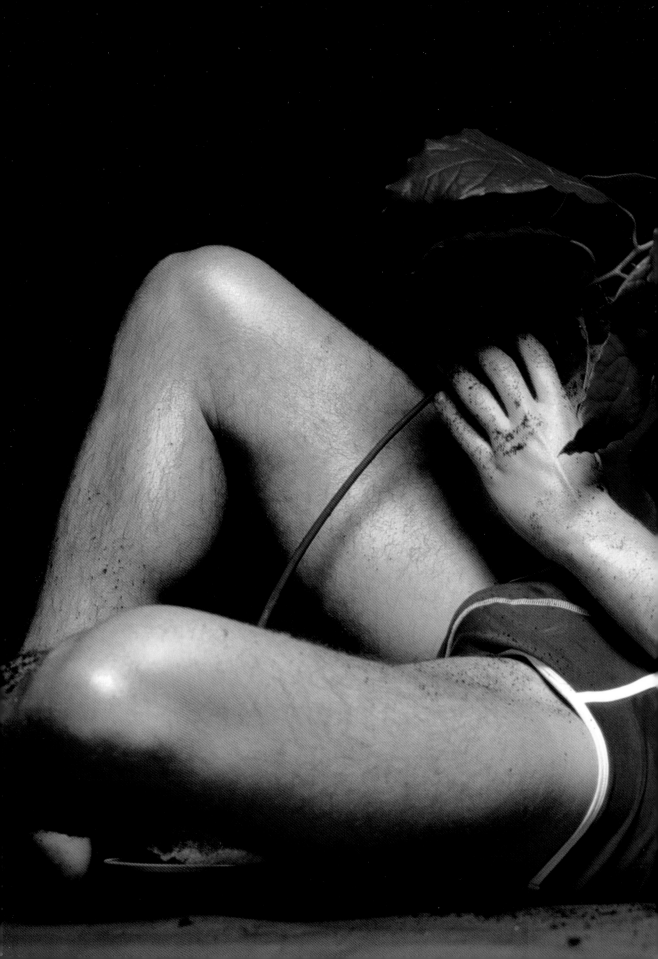

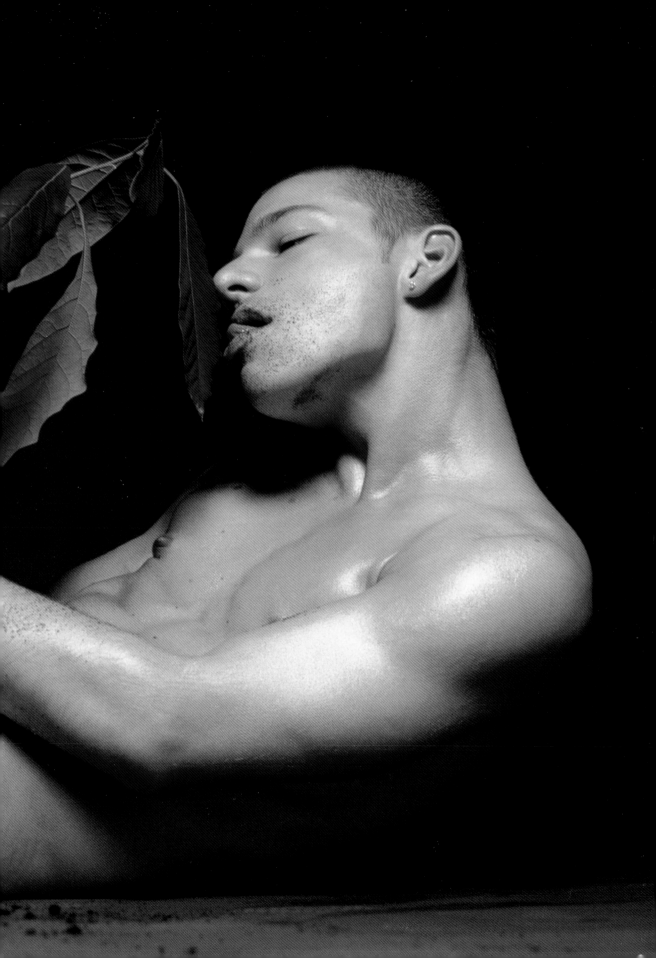

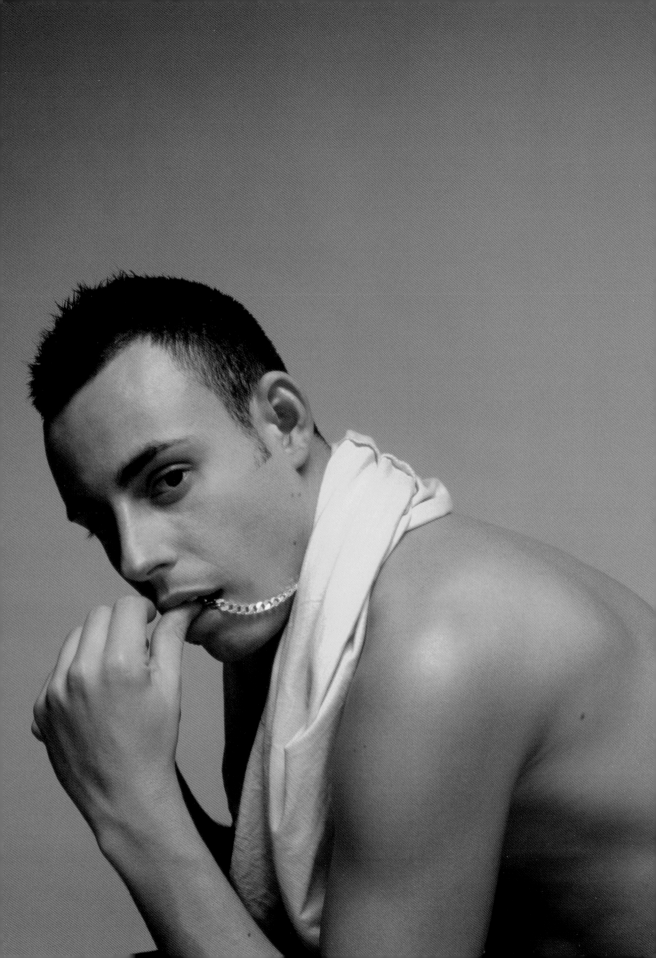

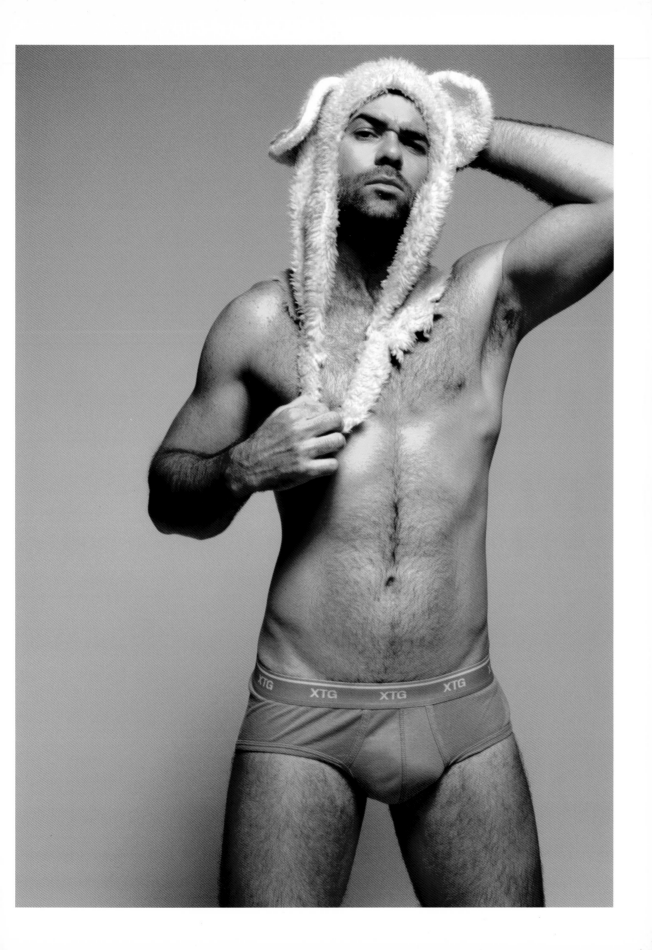

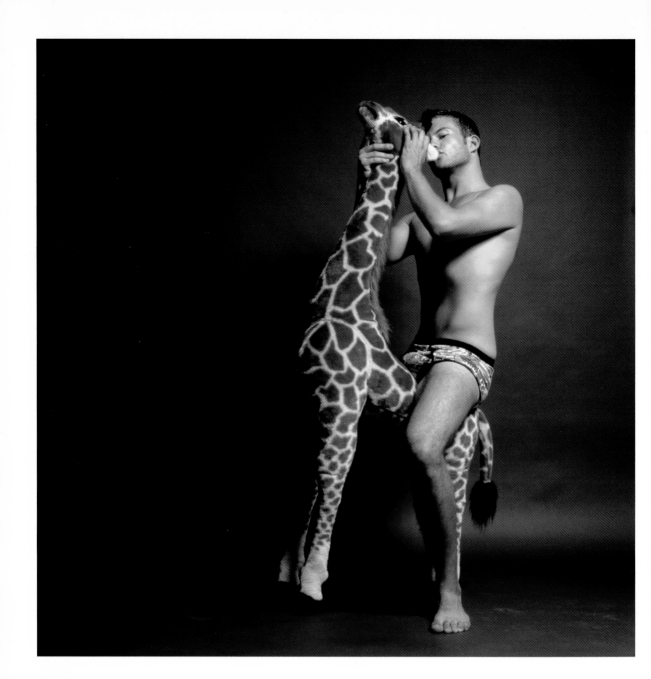

[64]

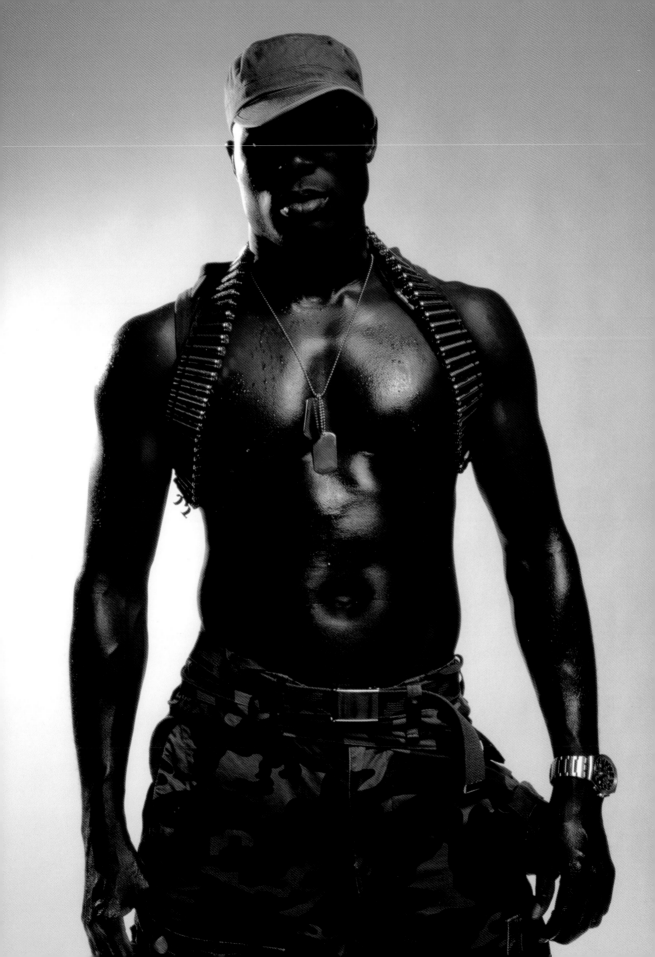

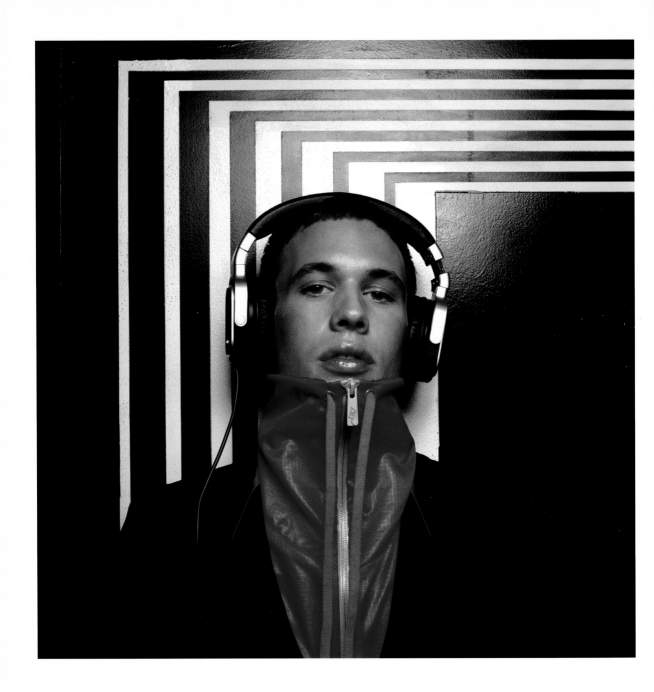

This book simply wouldn't be without you, thanks to Joris Buiks, Dominique Feusi, Déesse, Conchitta Limones, Lulu, André, Piero, Alain, Arthuro, Schnürlefanz, Madonna & Sam, Sadok, Martin, Lna, Roberto, Maria Lopez Thanks to the models Andy, Alen, Arno, Aziz, Christophe, Daniel, Demian, Enrique, Francois, Hugo M., Hugo C., Jean-René, Jodok, Jonas, Jorge, Kessie, Lukas, Malte, Marco G., Mc-Fly, Nicolas D., Nicolas K., Omer, Patrick, Pitbul, Q-Boy, Raphael, Remo, Rimus, Robby, Robert, Sandro, Simon, Tarcisio, Thomas N., Thomas T., Tim, Tobias.

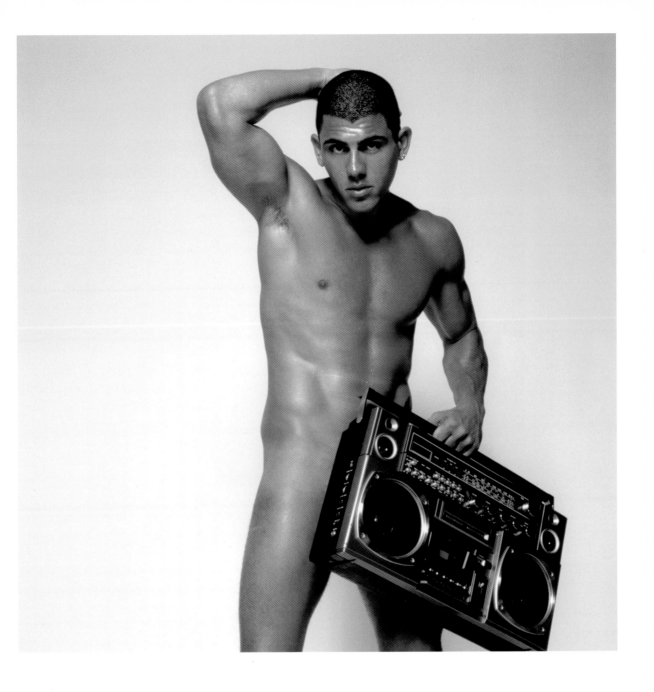

[thanks]

Thanks for eternal support to Peter & Zinetta at Visage Management Zurich, Florian & Raphael at Unique Models Zurich, Arthur & Paul at Angels Events Zurich, Javier at Analogon, Willis at Basis Fashion, Claude Bravi, Laurence Desarzens, Forecast, Cliff at QX, Jean-Pol & Fred at GUS, Spy at AKUT, Hugo Carrillo at Galerie B-146 Zurich thanks for styling and make up to Francis Ases, Basil, Bellezza, Athos De Oliveira, Eva De Vree, Lalotta, Lulùжpo, Rodrigo Soares, Daniel Spizzi, Yannick Zuercher This book is dedicated with all my love to my parents & Ueli

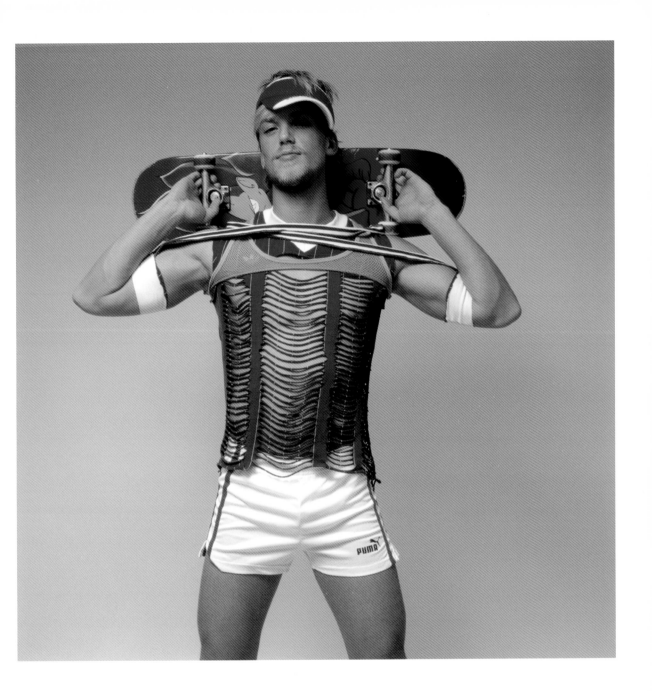

[69]

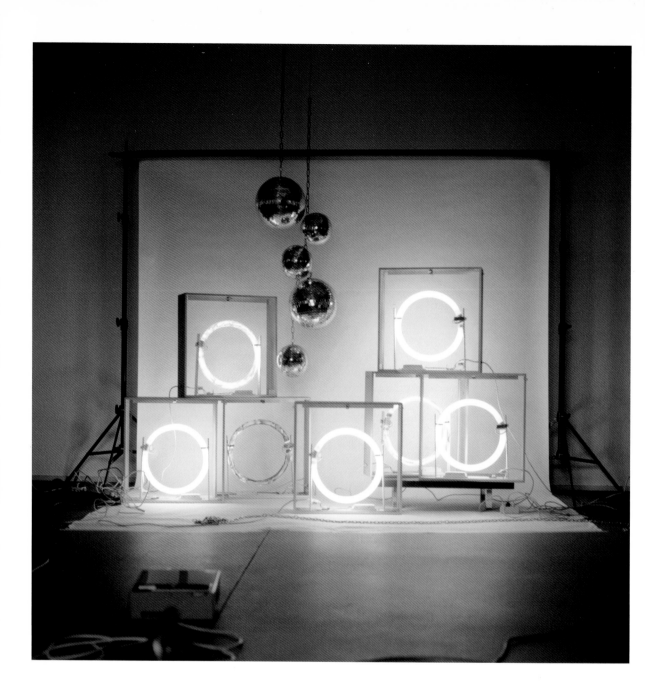

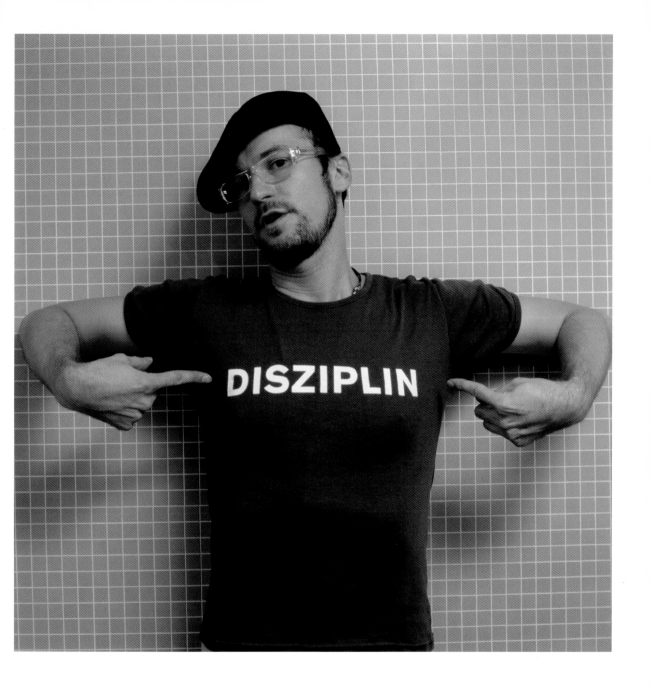

[about the artist]

Born in Switzerland in 1971, Patrick Mettraux studied photography in Montreal, Canada. Now based in Zurich, Switzerland, he works as a freelance photographer for various model agencies and magazines. Patrick Mettraux finds his visual energy in the contrasts between the positivism of things and elements and the power that results from them. His photos and collages have lightened the pages of numerous publications with an unique and sometimes odd sense of creativity.

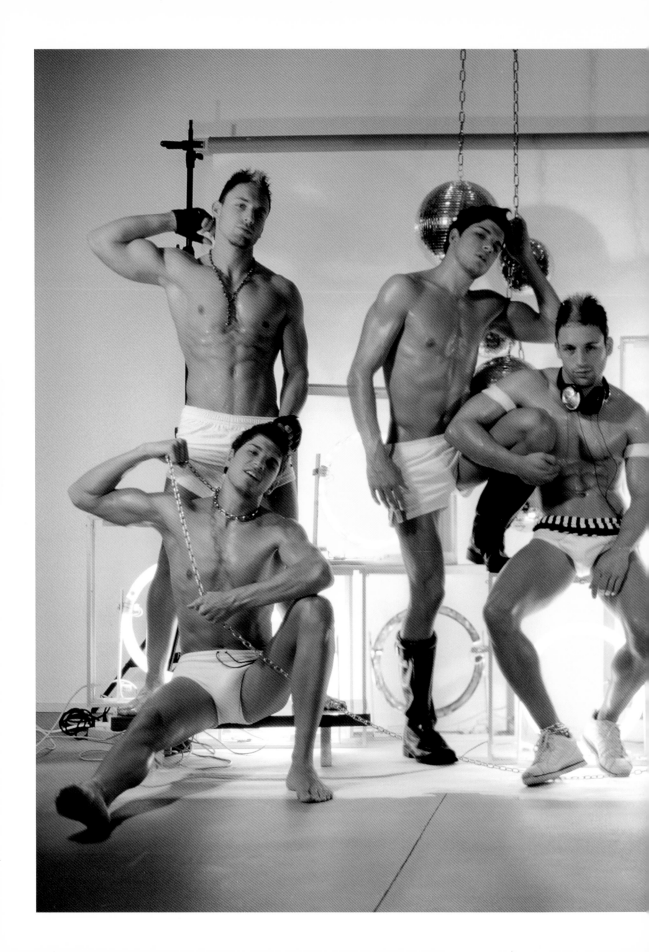

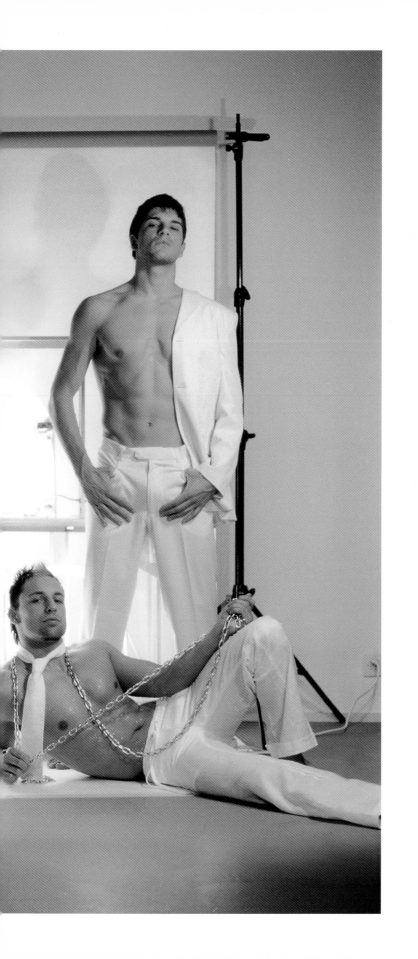

[74]

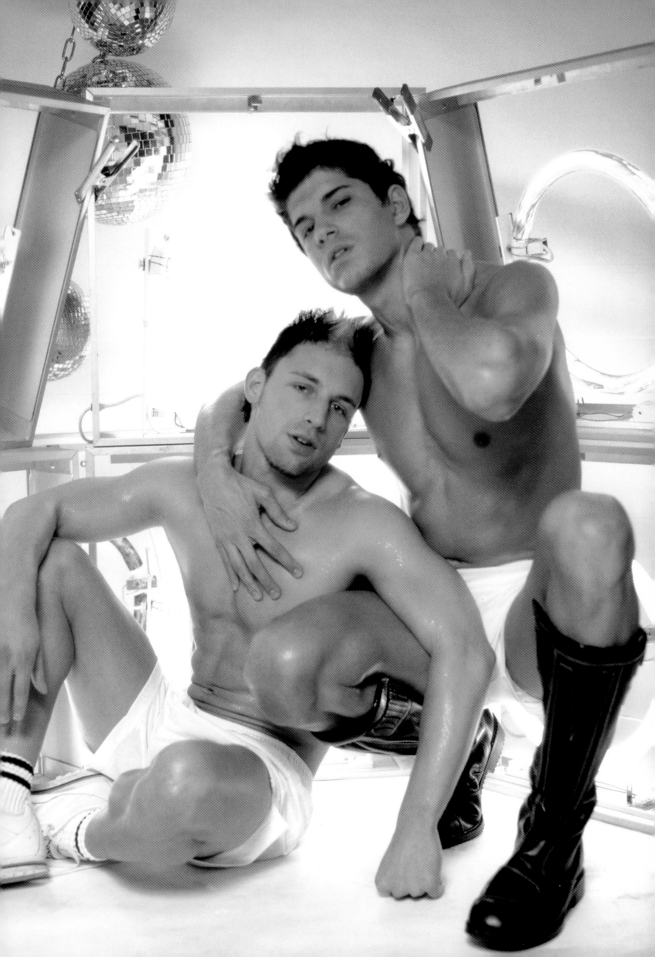

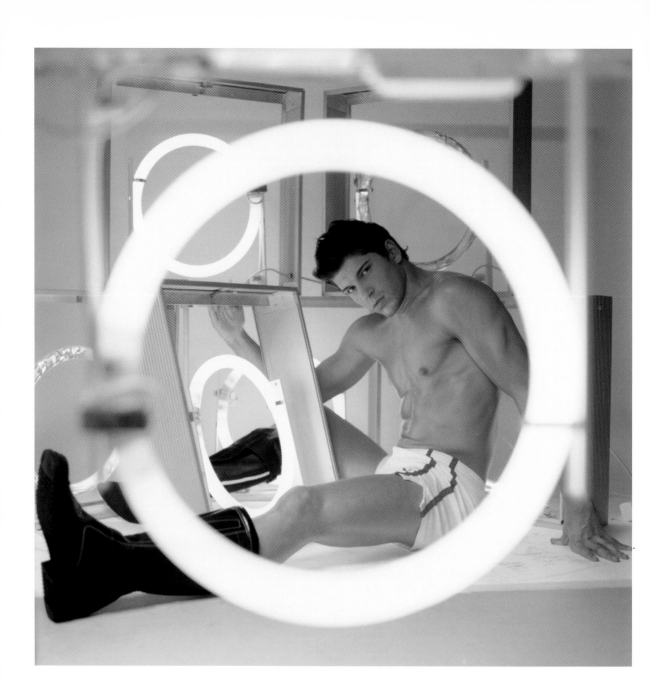

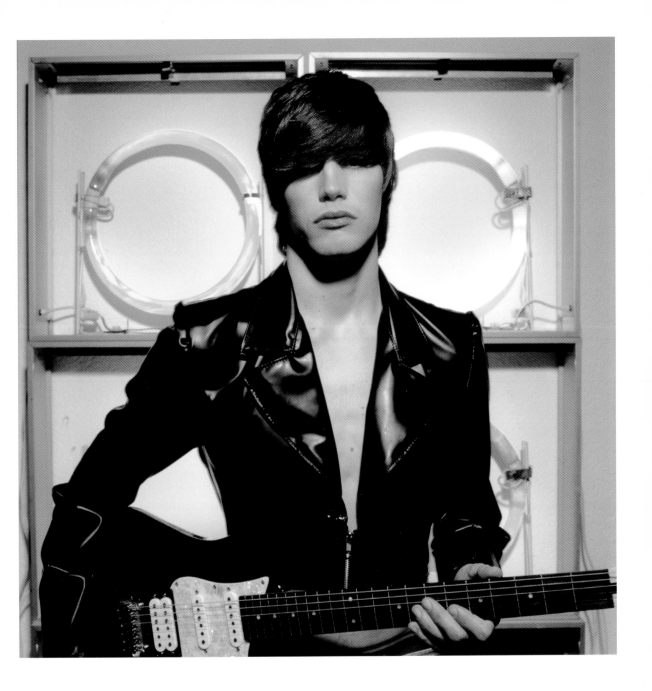

[77]

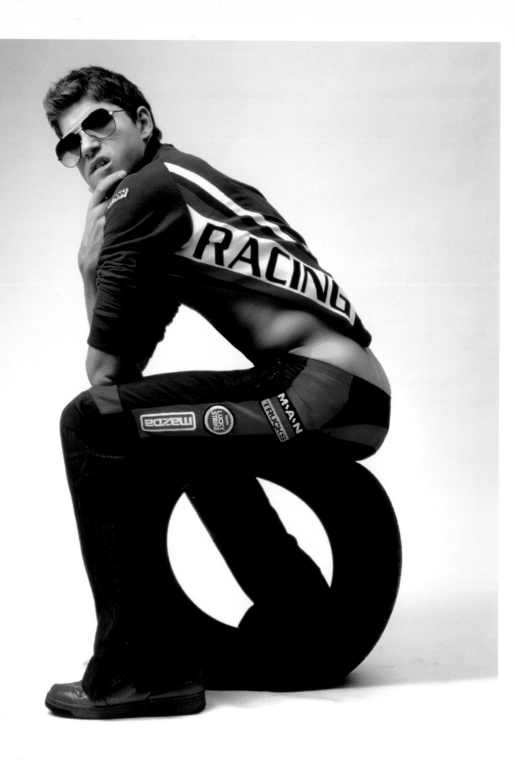

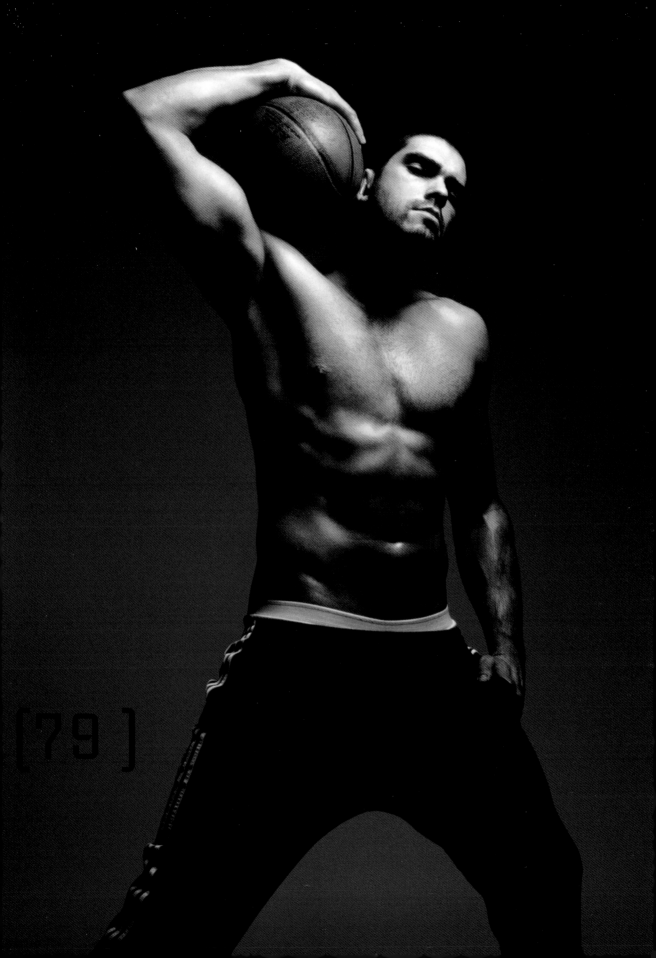

[79]

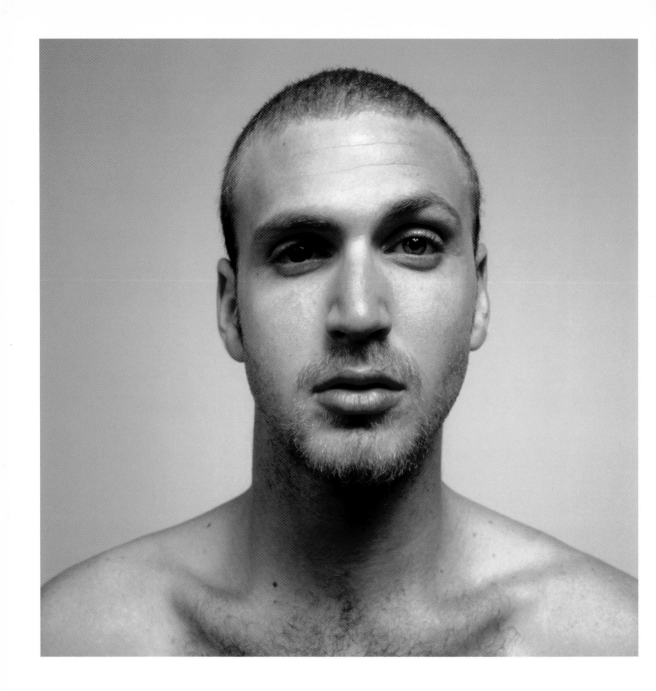

[80]

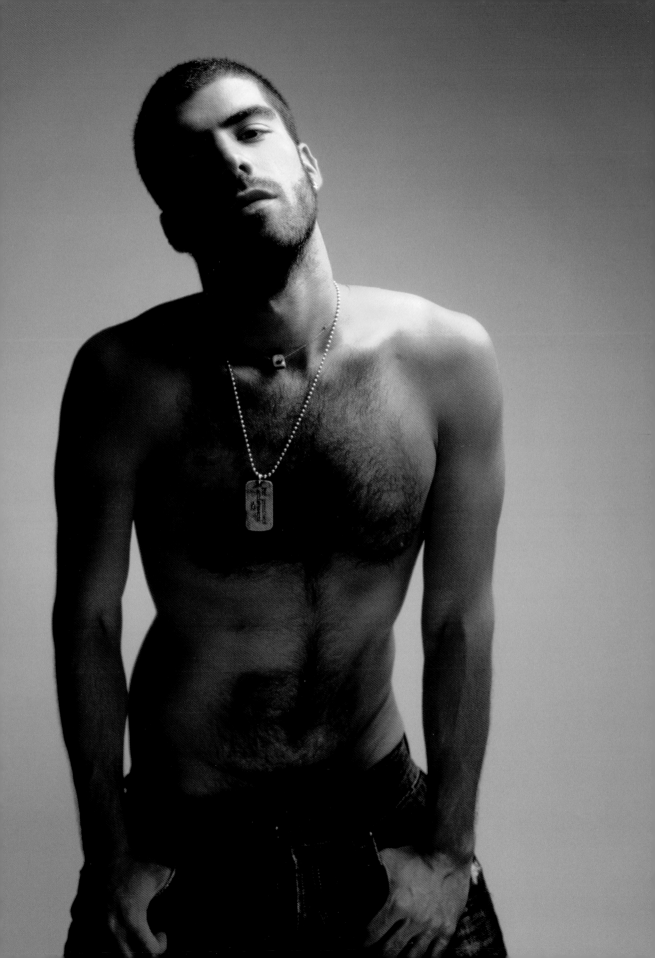

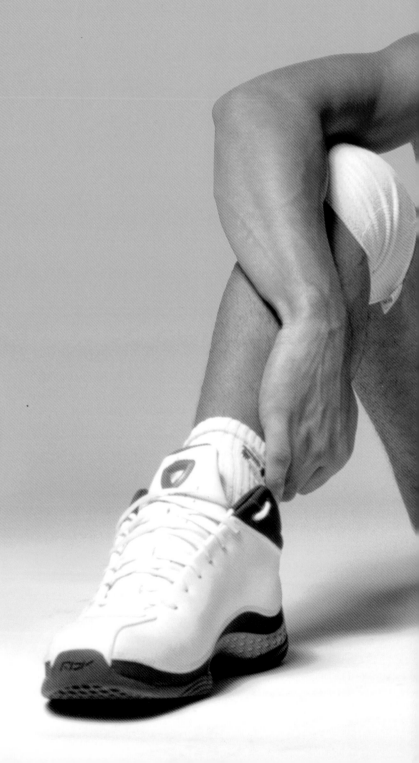

[82]

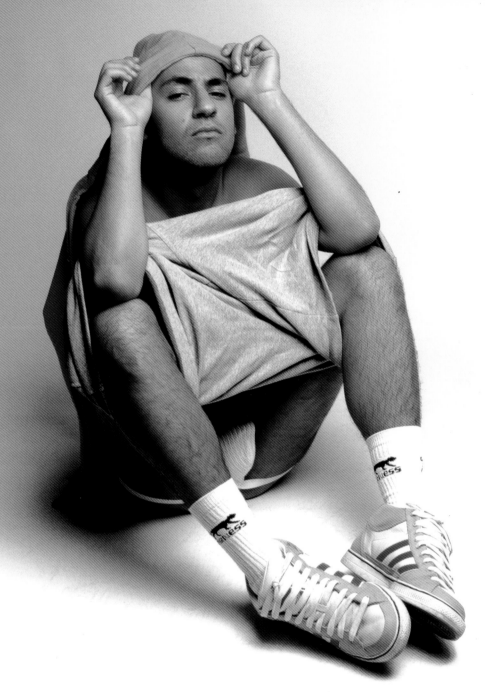

[87]

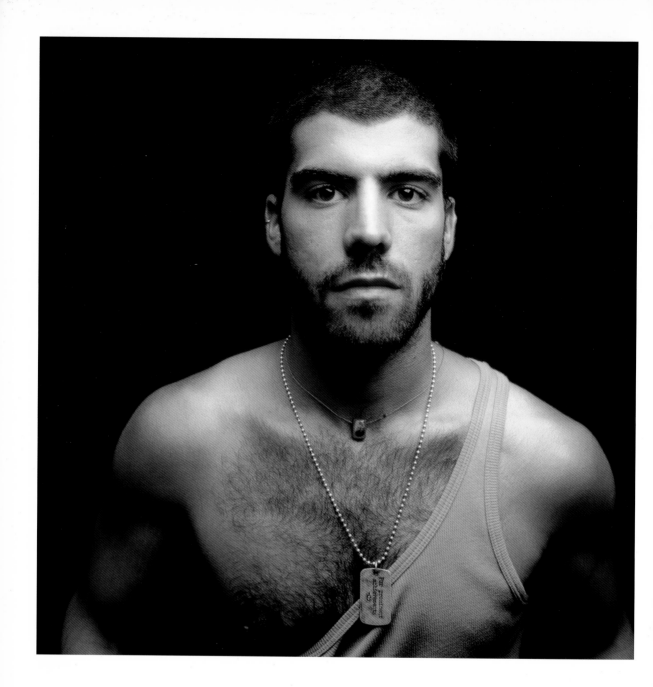

[88]

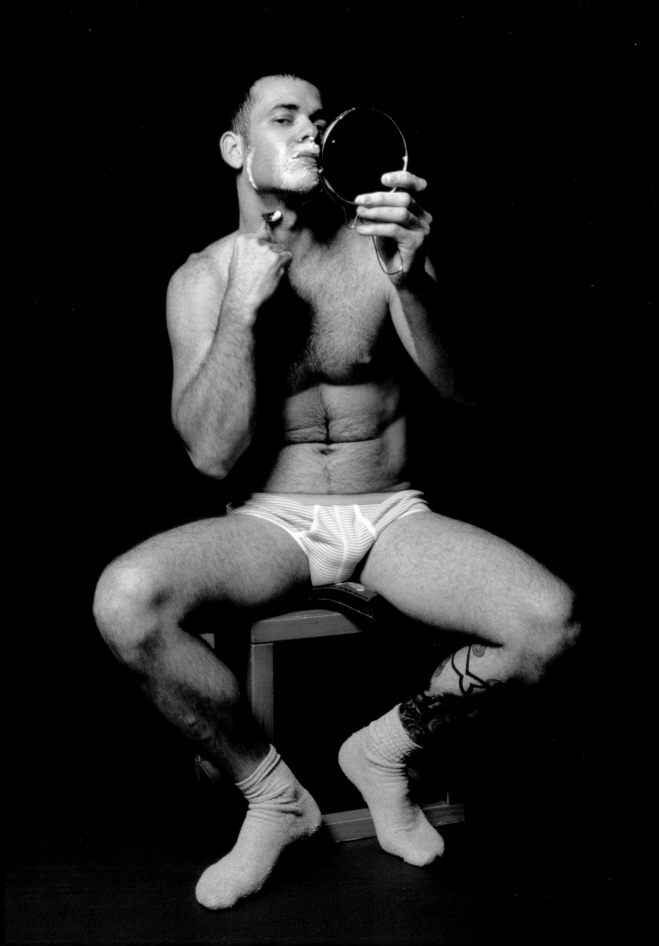

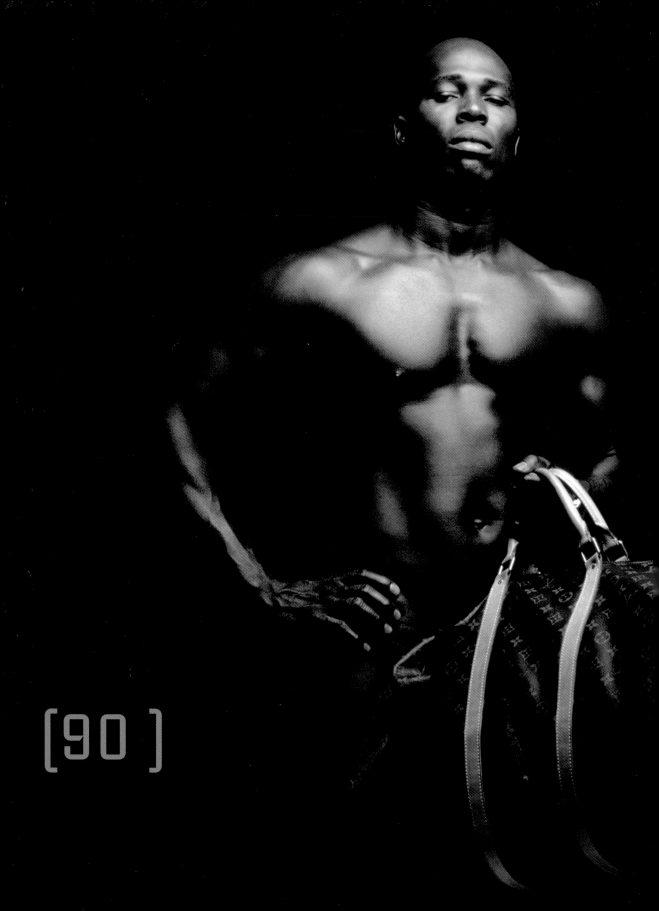

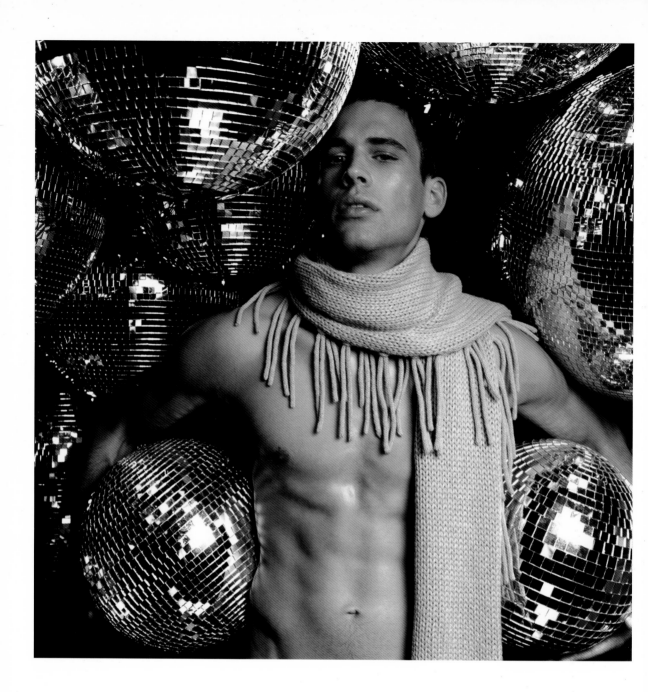

[92]

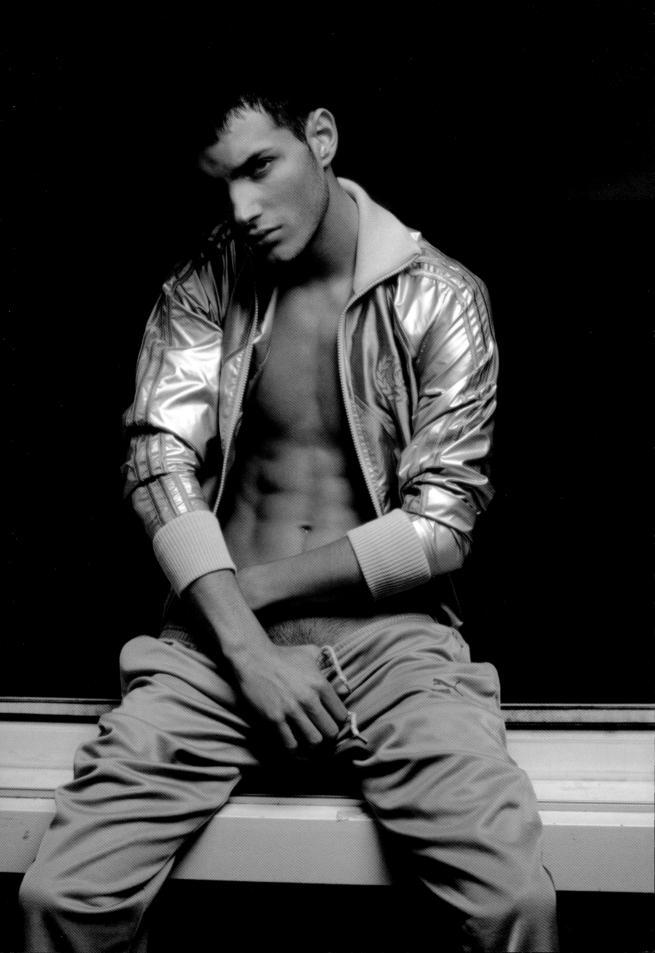

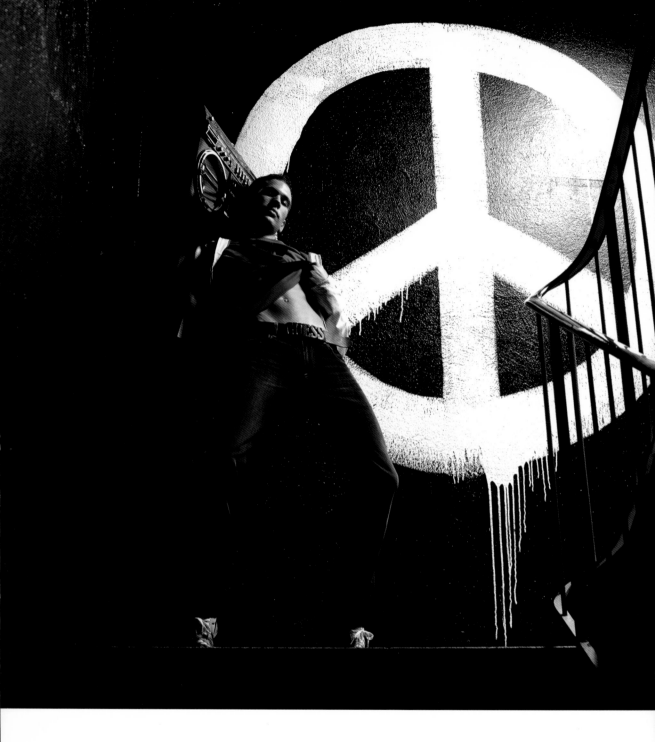

08 09 10 / 5 4 3 2 1
ISBN 978-3-86187-897-1
© 2008 Bruno Gmünder Verlag GmbH, Kleiststrasse 23-26, 10787 Berlin, Germany,
Phone: +49 (30) 615 00 30 info@brunogmuender.com www.brunogmuender.com
Printed in Czech Republic Edit & design: Joris Buiks pre-press: Holger Lindner

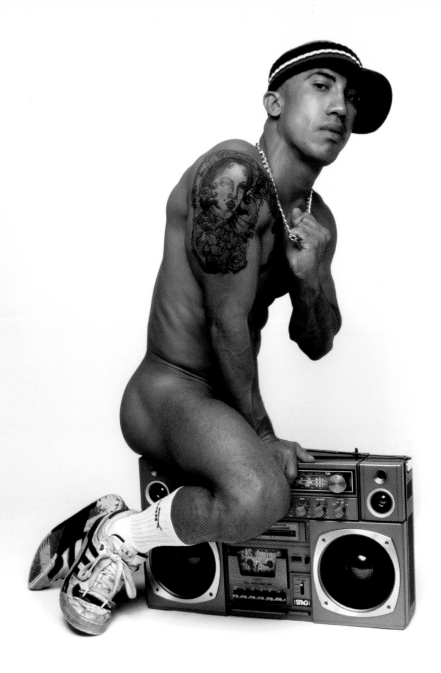

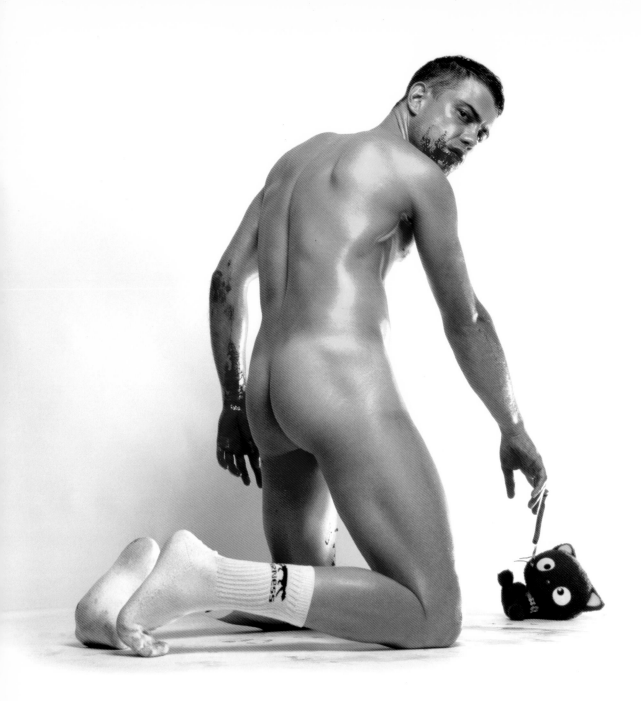